FEEDING HOPE

A Christian Counselor's Thoughts
on Therapy, Eating Disorders,
and the Healing Process

SUSAN DEAN LANDRY, LPC

Trilogy Christian Publishers A Wholly Owned Subsidary of Trinity Broadcasting Network 2442 Michelle Drive Tustin, CA 92780

First Trilogy Christian Publishing softcover edition December 2018

Trilogy Christian Publishing/ TBN and colophon are trademarks of Trinity Broadcasting Network.

For information about special discounts for bulk purchases, please contact Trilogy Christian Publishing.

Manufactured in the United States of America

10 9 8 7 6 5 4 3 2 1

Library of Congress Cataloging-in-Publication Data is available.

B-ISBN: 978-1-64088-201-0 E-ISBN:: 978-1-64088-202-7

Dedication

To my mom, who taught me to love and embrace Romans 8:28 and 2 Corinthians 12:9.

To my husband and better half, Adrien. Thank you for loving me and being my best friend for more than two decades.

And to Maridel and Cile: Thank you for keeping the butterfly alive.

Introduction

We are all recovering Christians, learning to apply the victory that is already ours—that has already been won for us at the cross by Jesus Christ. We fight from victory, as we learn our identity, power, and authority in Christ. Healing comes in many different forms. God uses people; He uses His Word. Sometimes He heals directly, on-the-spot. Usually, though, healing is a process. As a Christian counselor, here are some of my thoughts on that healing process, particularly as it pertains to eating disorders.

I've been writing articles for my website, www.NoMoreNumbers. com for more than a decade, so this is a collection of those articles and other similar "bite-sized nuggets" to chew on and digest!

My clients are my inspiration, my joy, my challenge, and my teachers. To past, present, and future clients: thank you. "All praise to our Lord Jesus Christ. God is our merciful Father and the source of all comfort. He comforts us in all our troubles so that we can comfort others." (2 Corinthians 1:3-4 NLT)

Foreword

Hope – this word is essential for today's world and for those who struggle with eating disorders. The world we live in is a very "messy" world. Messy in the sense that there are not a lot of simplistic answers to many of the issues people are dealing with in today's culture. "Messy," in the sense that these issues are full of many facets, issues, disappointments, hurts, emotions, trauma, and frustrations. Eating disorders are very real issues to millions of people; both females and males, and growing as a world looks for answers to deal with the issues they face.

Hope is the one word that brings encouragement to a world that appears to be dark, scary, and uncertain. Feeding that hope is essential for growth, but knowing how to access hope is a difficult process. Feeding Hope is a great work to give you directions on how to find the hope in the midst of the messy. Feeding hope is necessary to bring strength, power, purpose, and direction in ones life.

The person who, in my opinion typifies hope is Susan Landry. I have known Susan for over twenty years and from the moment I met her I have always been encouraged by her, her outlook on life, the hope she brings to life. She not only knows what she is talking about with her training as a therapist, but her heart of

compassion and love matches her ability, training and insight. I have watched her over these years grow as a therapist and literally change hundreds of people's lives. This work you are about to read will give you insight, will make you cry, will make you smile, but will most of all bring HOPE. Hope that you can do this, not just because Susan knows you can (which she does), but also because she knows the One who has all of the strength and insight necessary.

You can trust Susan, you can trust her heart, but most of all you can trust her God. So as you are reading this, take your time, and let the words of HOPE sink down deep into your soul, even if you don't want them there, and allow the words to feed your hungry soul so you can live and have life.

Ron Mumbower, Ph.D., LMFT

Contents

Do You Want to Be Healed?

Jesus asks this question in John 5:6 to the lame man by the pool. We've heard the story, and we've probably thought, *What an odd question. Of course the man wants to be healed, right?* Yet, this paralytic had come up with all kinds of excuses as to why he couldn't get into the healing waters of the pool that would make him well. It reminds me of the story in Mark 9:24 when the father of a demon-possessed boy exclaims to Jesus, "I believe; help my unbelief!"

I work with eating-disordered clients. Sufferers of eating disorders are notoriously ambivalent about change. They truly want something better, but it's hard to let go of that security blanket. It's as if their plea is this: "I'm willing to change; help my unwillingness!" Venturing into the murky waters of the unknown is scary. There is a grieving process that must take place as one says goodbye to that which provided a sense of safety, an identity, predictability, and a feeling of control. A favorite quote of mine is by author and theologian Kent Nerburn who says, "No amount of security is worth the suffering of a life lived chained to a routine that has killed your dreams." That is exactly what an eating disorder does. It kills the desire to fulfill one's God-given purpose.

My belief is that a person with an eating disorder is not (as is commonly believed) a person who is vain; he or she is a person

who is in pain. The illness, paradoxically, relieves that pain while creating all sorts of other problems. Sentiments uttered by my clients (and as a former sufferer myself) sound something like this, "I want to get better, but I am so afraid of what that might mean." A healthy part exists within each of us that wants healing, but the eating-disordered part, or the addicted or enslaved part that is bigger and terrified of change is in charge.

Clients have to believe that what we as counselors have to offer is better than that to which they are clinging. This is quite difficult to believe, and we have to help their unbelief! Furthermore, we have to motivate them to become willing to change. We have to coax them into the unfamiliar, and they must trust us to lead them on that journey.

Galatians 5 tells us that "it is for freedom that Christ has set us free." (Galatians 5:1) I want my clients to understand that while their resistance to change is understandable, they are not free. Author Marilyn Ferguson writes, "Ultimately we know deeply that the other side of every fear is a freedom." When we realize that we are not free—that we lack the freedom Christ died for us to experience—then we truly do want to be healed.

I Am a Dot…and Other Life Lessons

Appropriate for Thanksgiving is Psalm 8 which declares, "O Lord, our Lord, how majestic is your name in all the earth." (Psalm 8:1, ESV) On a recent vacation in Wyoming, I marveled at the indescribable beauty of God's creation. We need only see the mountains, a sunset, or a winding river to know we are privileged to call the magnificent Creator our beloved Father.

"When I consider your heavens, what is mankind that you are mindful of him, human beings that you care for them; you have crowned them with glory and honor." (Psalm 8:3-4)

On this trip, I had the extraordinary experience of hang-gliding. While soaring to nearly 6,000 feet over the Tetons, I thought of Isaiah 40:31, "Those who wait upon the Lord will soar on wings like eagles." A photograph captured from the ground reveals that I am comparable to a dot. In the grand scheme of things, we truly are "dots," yet God made us a little lower than the angels and put all creatures under our feet.

My other big adventure was white-water rafting. Traveling down the Snake River, I was awed by the majesty our Father has put on display for our enjoyment. At one point, I was swept out of the

raft while hitting some treacherous rapids. I later remembered that in Isaiah 43 it says, "When you pass through the rivers, the waves will not sweep over you...do not fear for I am with you." (43:2, 5a) When the freezing-cold waves were literally sweeping over me, I was not reciting Scripture; I was trying not to panic, as instructed. However, I realized that God did not allow me to sink, drown, or be thrown against a rock. My guide was able to pull me safely back into the raft.

You may be asking yourself what all of this has to do with counseling? Well, before one can soar on the wings of eagles, scripture says we must wait upon the Lord. What does waiting mean? It means trusting when everything is falling apart. It means accepting that there is no easy solution. This may involve obtaining an objective perspective from a professional who can compassionately offer alternatives.

Also, I learned about the importance of a guide. I needed an experienced pilot to maneuver the hang-glider. When, not if, we pass through the rapids of life, we need a helping hand to pull us out. Confused and conflicted clients can look to a counselor to lead them out of danger. A counselor can trust God for a client's healing, even when that client sees no way out of the pain. People seek counseling when they feel as though they are drowning and the dark waters are swirling all around them. With God's help, a counselor can pull them back into a safe place. Finally, despite what happens, we can be thankful. We can offer a sacrifice of praise even when this life seems unbearable. "Let them give thanks to the Lord for his unfailing love and his wonderful deeds for mankind." (Psalm 107:15)

Launching into Recovery

Much has been accomplished to promote awareness and prevention of eating disorders in recent years, and there is still work to be done in this area. Assuming that prevention efforts have failed, someone in the midst of a full-blown case of anorexia, bulimia or binge-eating disorder needs an idea of what treatment involves. It is tailored to the individual, with nutritional counseling and medical evaluations, while also focusing on emotional and spiritual needs. Therapy may address trauma resolution, assertiveness training, relationship issues, and body image concerns. As clients learn new solutions to life's difficulties, they replace destructive eating patterns with more satisfying coping skills. Self-esteem improves as one recognizes his or her value as a unique and worthwhile individual.

When you're in bondage to an eating disorder, you are blind to the truth that something exists beyond this life you're living. Even when it feels like bondage, at least disordered eating behaviors are predictable and seemingly controllable...and preferable to life's harsh realities. I want clients to know that they need not become complacent, settling for the comfort of their disorder. This tendency is especially true when recovery seems too difficult or even impossible. Together, we must find something that is more important and more appealing than the eating disorder. He or she must discover or re-discover a passion, a talent, or a

purpose. As clients move away from the imprisonment of the ED, they must move *toward* something. That might mean a career, a relationship, or starting a family. These things cannot co-exist with an active eating disorder.

Desperately clinging to the security of anorexia or bulimia makes it impossible to have truly intimate relationships with others, or to passionately pursue one's dreams and talents. May those in need of recovery find the courage to launch into the treatment process. Dare to move out of your comfort zone into the unfamiliar, and may you be amazed with what life has in store for you!

Do I Look Fat?

Ah, summer. Fun in the sun. For many, that is synonymous with two dreaded words: "swimsuit season." We live in a weight-obsessed culture, one that glorifies thinness. For ten million girls and women in this country, and for nearly one million boys and men, this quest for the "perfect body" leads to life-threatening eating disorders such as anorexia and bulimia. Without treatment, five to twenty percent of individuals with severe eating disorders will die.

Many factors combine to contribute to the development of an eating disorder. Some of these include low self-esteem, perfectionism, feeling inadequate or out of control of one's life, troubled family relationships, peer pressure, media influences, depression or anxiety, and genetic tendencies.

People often turn to an unhealthy obsession with dieting and body dissatisfaction because they have learned that their worth and value is dependent upon their appearance and achievements. We need to focus on what's inside. We need to challenge ourselves to build inner character, not just better bodies. Psalm 139 says, "I praise you for I am fearfully and wonderfully made." (Psalm 139:14) We are God's works of art.

We also need to challenge ourselves to get real about the media images bombarding us daily. These images have been taped, tucked, airbrushed, and altered. Fashion models are thinner

than ninety-eight percent of women in the United States, and Americans spend forty billion dollars a year on diet-related products! Seems like a waste, doesn't it?

"Do not conform to the patterns of this world, but be transformed by the renewing of your mind." (Romans 12:2) Sounds like wise advice.

People with eating disorders and body image disturbances use this focus on food and weight as a way to cope with feelings and situations. Rather than know how to handle legitimate emotions, they've learned to channel them into "fat feelings." They must learn how to build self-esteem, strengthen healthy relationships, and turn to a loving Father to comfort them and strengthen them in the storms of life.

Parents: instill healthy eating and exercise habits in your children, modeling balance, variety, and moderation, but affirm them for who they are rather than for how they look. Teach them that they are more than a number on a scale. Help them develop their inner beauty and character. Don't berate your own bodies in front of your children.

It's tough to feel good about our bodies in a body-conscious world. We all have flaws and imperfections that we wish we could change, but we must put it in perspective.

Women, challenge yourself to eliminate the question "Does this make me look fat?" from your daily conversations.

Diet-conscious parents, refrain from discussing calories, carbs, fat grams, and dress sizes in front of your impressionable pre-teen. Practice the language of feelings instead of the "language of fat."

So this swimsuit season, let's focus on what's important: fun with family and friends, deepening our faith, and remembering that God cares about what's in our hearts, not the size of our thighs.

A Day in the Life

I am fat; I hate myself; why did I do that; why did I eat that; why did I say that; they hate me; I hate myself; God, do you hate me? God, help me; God, kill me.

If I can make it until noon without eating, then I will be okay.

If I can run off all the calories I consumed yesterday, then I will be okay.

If I can make it through this meeting and then go buy binge food, eat it and purge, then I will feel empty and can make it.

Okay, the scale says this, therefore, I can breathe. I can make it through this day.

I'm going to try this new diet, and I am hopeful again.

The scale is down. I'm a good person today.

I have to be faster than yesterday. I have to go farther than yesterday.

I'm afraid to eat that. What if I choke? This feels safer. I feel more in control if I can eat this.

What are these ingredients on this nutrition label? Are these acceptable?

I am fat; I hate myself; why did I do that; why did I eat that; why did I say that; they hate me; I hate myself; God, do you hate me? God, help me; God, kill me.

Which of the eating disorders do these statements characterize? All of them: Anorexia Nervosa, Bulimia Nervosa, Binge Eating Disorder, ARFID (Avoidant Restrictive Food Intake Disorder), OSFED (Other Specified Feeding and Eating Disorders), compulsive exercise, and orthorexia (an unhealthy fixation with eating only foods that are deemed "healthy").

A person in recovery experiences changes in his or her prayer life and relationship with God, self, and others.

"God, fill me with your Holy Spirit. May I overflow with the fruit of the Spirit. May I manifest the supernatural gifts of the Spirit. Empower me, Lord, to fight this good fight of faith. Help me recognize the lies of the enemy and refute it with the truth of my identity in Jesus Christ."

"Do you not know that your bodies are temples of the Holy Spirit, who is in you, whom you have received from God? You are not your own; you were bought at a price. Therefore honor God with your bodies." (I Corinthians 6:19-20 NIV)

The Myth of the Magic Wand

Why, if we are to "pray without ceasing," did the Apostle Paul ask God only three times to remove the thorn from his flesh? I never understood why he did not keep asking. Finally, I realized that Paul stopped his requests because his prayer was answered: God's grace was sufficient. God would allow Paul to suffer so that His glory would be made manifest. God utilized trials in Paul's life, in Job's life, in Joseph's life, and in the lives of countless others in order to bring glory to Himself. He allows tribulation in our lives so that He can pour his grace into our woundedness and shine through us. He does it so that we can be molded into the people He wants us to be. If a butterfly emerges from its cocoon prematurely, it is not strong enough to fly. Similarly, if we are magically healed, we miss out on the transformation that occurs on the Potter's wheel. God uses trials to strengthen us, to depend on Him, and to enable us to be comforters to others.

People seek counseling for many reasons—they may be struggling with an addiction, a marital crisis, grief issues, or job stress. Usually all hope for an easy, quick solution. Counselors are no different in this respect. We want to "fix" people and put an end to their pain. Unfortunately, there is rarely a situation for which a quick fix exists. I often hear clients say that they wish there were an easy way out; they wish their problem could instantly be cured;

they hadn't expected to work so hard. I often find myself saying, "Believe me: if I had a magic wand, I'd use it." But there is no such thing as a magic wand. In order for healing to occur, one must embrace the process and go through the painful valley. One of the difficulties that people encounter in therapy is the fear of change. When the pain of remaining the same hurts more than the pain of change, people are willing to go through the process.

As a counselor, I may not have answers, but I can offer alternatives and assistance. I may not have the solution, but I can offer solace in one's suffering. I may not be able to heal, but I can offer hope. We have a Good Shepherd who promises to be with us as we walk through the valleys, and we have the Wonderful Counselor present with us in the therapy room.

God doesn't give us a magic wand, but He gives us an unlimited supply of mercy and grace. He gives us strength when we are weak, an easy yoke when our burden is heavy, His promise to keep us from falling though we stumble. And He uses circumstances to mold us into vessels fit for His use.

A Thief of Joy

"Comparison is the thief of joy." –Theodore Roosevelt

Lately this has become my favorite quote, and in our media-driven, approval-seeking culture, I find it to be truer than ever. A recent article cited a BBC interview with actor Denzel Washington who asked this rhetorical question: "Are you using your phone, or is your phone using you? Can you put it down? Can you turn it off?" He went on to say that he's not knocking the smartphone, but we have to at least ask ourselves what our phones are doing to us.

This article (by Tony Reinke, author of *12 Ways Your Phone is Changing You*) explains how the endless need to gain approval and popularity has lost its boundaries. For all demographics, challenges persist such as "the inability to simply walk through the late spring breeze without the itch to reach for a mobile device."

Studies show that our ever-increasing reliance on smartphones results in inactivity, obesity, stress and anxiety, sleeplessness and restlessness, bad posture and sore necks, eye strain, headaches, and even loneliness. We become addicted to distraction, ignoring those around us, craving immediate approval, losing our literacy and ability to concentrate.

Reinke goes on to say that "we become what we most love" and

that basically, "whatever we focus our attention on is the thing we are becoming. "We can also become uncharacteristically harsh with one another while hiding behind a little screen. We are "being distracted to death."

With social media our society has become obsessed with how many "likes" we get on Facebook, Instagram, etc., and with comparing our bodies to unattainable (and fake) images. In doing so, we lose touch with meaning and purpose and value and identity.

I'm not even a huge consumer of social media, but I know my attention span has been greatly reduced because of the need to constantly respond to every ping and notification on my phone. When I turn it off or leave it at the house, I have learned that I experience much greater peace. Mindlessly scrolling can instantly lower my mood when instead I can gain so much more from reading a book, taking a walk, or having an actual conversation.

We are bombarded with the latest diet or fitness craze (which can change daily), and in doing so, we forget that eating disorders are severe mental illnesses. In the words of Carole Lewis, a treatment professional in Houston, "to give emotionally wounded people only a weight-loss plan is like putting a band-aid on a cancerous lesion."

Of course, all social media is not bad: it can certainly be used for good and to promote positivity, or to stay connected with people far away. It can offer support, foster friendships and keep people updated on the news. Laughter and diversion and supportive networks are all essential to mental health. But when it promotes constant competing and comparing and negativity, it has the potential to kill, steal, and destroy (what the Bible says the enemy comes only to do). Balance and moderation are key. Look up, look around, and remember this: "My business is not to remake myself, but to make the absolute best of what God made." (Robert Browning)

Becoming Childlike

The prophet Isaiah foretells Jesus' coming by saying, "and a little child will lead them." (Isaiah 11:6b)

It seems we've been in the middle of the Christmas season since Halloween, doesn't it? Alongside aisles of candy and costumes are stockings and pre-lit reindeer for sale. And every year, it feels as though the adage "Christmas is for the kids" is so true. We see the hope and joy of the season through the eyes of children, excitedly anticipating what awaits them under the tree. But, the child who came over two thousand years ago brings all of us the possibility of hope and joy. Adults tend to lose the enthusiasm associated with the holidays because, well, adulthood can be downright difficult. This is especially true for those who are alone at Christmas because of divorce, widowhood, or an empty nest. The loss of joy and hope in situations such as these brings many people through the doors of the counseling office.

Yet, hope came down in the form of a little child. Joy came to this world in the form of a little child. Our Savior came as a little child and would later tell His disciples, "Let the little children come unto Me." (Matthew 19:14) He also said that "unless you change and become like little children, you will never enter the kingdom" and "whoever humbles himself like this child is greatest in the kingdom of heaven." (Matthew18:2-4)

Many of my clients think that in order to "get right" with God, or to come into His presence, they need to clean up their act, improve themselves, achieve something, and then God will accept them. They have it backwards. Why did God tell us we must become as little children? Did he mean that children are innocent, and therefore we have to make ourselves innocent before he will care about us? If you've ever spent much time around small children, I bet you hardly see their behavior as blameless. No, Jesus knows we have to recognize our helplessness before we can see Him as our only hope. There is not a more helpless creature on earth than a newborn human! We come into this world utterly dependent on our caretakers.

How do you need to become like a little child? Do you need to humble yourself and receive Christ, who came to earth as a baby, lived a perfect, sinless life and died in your place? Or maybe you have done that, but you need to humble yourself and seek wise counsel as you struggle with your personal difficulties. We weren't meant to live in isolation; God uses His children to bring about healing and restoration amongst His children. You and I are His instruments, here to help each other along the way.

Like a little child, we can be excited and exhilarated about Christmas. When we humble ourselves, we become ready to receive salvation. We receive help. When we humble ourselves and become like little children, we experience joy, hope, and a place in a new family—the family of God.

"I praise you, Father, Lord of heaven and earth, because you have hidden these things from the wise and learned, and revealed them to little children. Yes, Father, for this was your good pleasure." (Matthew 11:25-26)

Young White Female

That's the stereotypical image people have of the eating disorder sufferer. However, eating disorders do not discriminate. They affect people of every age, race, gender, and socioeconomic status. For example, The Alliance for Eating Disorders Awareness states that "eating disorders currently affect approximately 25 million Americans, in which 25% are boys and men." According to this estimate, 6.25 million males suffer from anorexia, bulimia, and binge eating disorder.

The National Eating Disorder Association gives statistics on the ED symptomatology experienced by African-American, Asian-American, Hispanic-American and Native American women, revealing that these minority populations are suffering at increasingly higher rates. Disordered eating, body dissatisfaction, drive for thinness, and other measures were not so different from white girls studied.

Harboring the attitude that these diseases exist only among a certain population does a huge disservice to so many who are desperate for help but also reluctant to seek help—out of fear or shame, or because of cultural mores, or because their struggle is minimized by the professional community.

Even the young white female does age. Many women in my

practice who are in their thirties, forties, fifties, and beyond share eating disorders that began in adolescence. Other women do not experience full-blown symptoms or even any disordered habits until middle age. Often, life transitions such as marriage, pregnancy, grief, and loss can trigger a relapse.

The National Eating Disorders Association has chosen "Everybody Knows Somebody" as its theme for ED Awareness Week several times in recent years. This campaign brings public attention to the critical needs of people with eating disorders and their families. National attention is brought to the severity of these bio-psychosocial illnesses with potentially devastating, life-threatening consequences. While there is hope and recovery is possible, without early intervention many people suffer with long-term effects.

The Gift of Pain

There is a rare but real disease in which the afflicted person lacks the capacity to feel physical pain. Initially, that almost sounds like a blessing; however, imagine not knowing that your hand is on a hot stove, only to learn later that you have third-degree burns. Pain is a signal that something is wrong. It is necessary for our protection in this world.

Similarly, emotional pain is an essential indicator that something is amiss and needs to be addressed. The thought of being immune to emotional suffering is understandably attractive; in fact, many of the solutions to which we turn in the midst of troublesome circumstances are an attempt to remain "comfortably numb." These might include substance abuse, eating disorders, workaholism, etc. Even self-injury is a way to give emotions an outlet, or to mediate inner turmoil. People find ways to avoid feeling negative emotions, but in doing so, they fail to move through the healing process. They also make it impossible to feel joy.

Fear, anger, sadness, loneliness...these emotions hurt! We want to ignore them and suppress them. Yet these are signals that something is wrong in our environment, and they motivate us to choose appropriate behavior. A healthy fear of a would-be attacker prompts one to fight or flee. Righteous anger towards a

child abuser urges one to seek justice. Remorse when conviction leads to repentance. Mourning the loss of a love allows one to be comforted. Experiencing loneliness moves one to seek companionship rather than keep people at a distance out of a fear of rejection.

Many Christians falsely believe that our feelings are insignificant, that for example, it is wrong to experience a negative emotion. God created us with feelings, and encourages us to express them. The Psalmists poured out their feelings to God, and in turn, they received comfort and strength and renewed hope. We are designed to cry, to appropriately express anger, to seek relationship—just as Jesus did when He walked this earth. And when faced with hardship and temptation and unimaginable agony, we also cry out to the Father for strength.

Experiencing physical pain may lead one to seek necessary medical care. It would be foolish to ignore the clear warning signs of a heart attack. In the same way, a person experiencing emotional suffering is wise to ask for help. Take your pain and brokenness to the Lord. It has been said that we become "strong at the broken places." Allow a counselor to help you sort through your feelings, identify them, determine if they are rooted in false beliefs, and learn to express and respond to them in a healthy way. We cannot merely "get over" painful circumstances; instead, we must go through them in order to heal. In Romans, we read that "suffering produces perseverance; perseverance, character; and character, hope. And hope does not disappoint us, because God has poured out His love into our hearts by the Holy Spirit." (Romans 5:3b-5a)

God wants us to be real. He wants us to come to him rejoicing, but also pleading, desperate, afraid, alone…He longs to be a loving Father to the precious children He gave everything in order to adopt as His very own beloved. Because Jesus walked as a

man, he has experienced every human limitation and temptation that we all have; he bore all of that on the cross after leaving the glories of heaven and living on this earth *so that* we can come to him, knowing and trusting that He understands, sympathizes, and advocates on our behalf before the Father. God longs for us to come to Him with any and every problem—nothing too big or too small. When hope seems scarce and illogical, run with an open heart, pouring out your pain to a loving God, Creator of the Universe, who cares about every detail concerning us—large or small. What a privilege it is to "cast all our anxiety on him because He cares for you." (I Peter 5:7)

*** "Real isn't how you are made,' said the Skin Horse. 'It's a thing that happens to you. When a child loves you for a long, long time, not just to play with, but REALLY loves you, then you become Real.'

'Does it hurt?' asked the Rabbit.

'Sometimes,' said the Skin Horse, for he was always truthful. 'When you are Real you don't mind being hurt.'

'Does it happen all at once, like being wound up,' he asked, 'or bit by bit?'

'It doesn't happen all at once,' said the Skin Horse. 'You become. It takes a long time. That's why it doesn't happen often to people who break easily, or have sharp edges, or who have to be carefully kept. Generally, by the time you are Real, most of your hair has been loved off, and your eyes drop out and you get loose in the joints and very shabby. But these things don't matter at all, because once you are Real you can't be ugly, except to people who don't understand." ***

- Margery Williams Bianco, *The Velveteen Rabbit*

Addictions Model vs. Full Recovery

Many people grasp a better understanding of eating disorders by assuming that they are similar to alcohol and drug addictions. Therefore, they conclude that a twelve-step approach is the most effective way to treat such disorders, including anorexia and bulimia. These complex illnesses, however, do not fit so neatly into the little boxes constructed by the addictionology field. Throughout the twelve steps and the accompanying literature, numerous themes and concepts can be quite applicable to eating disorders: e.g. embracing the idea that a Higher Power can bring about restoration; as well as replacing the addiction with improved relations with God, self, and others.

A stumbling block inherent in the Addictions Model, i.e. the twelve-step approach, is the idea that one will always be sick, and sufferers will forever be fighting those constant battles and voices. This never-ending process of "recovering" revolves around following strict rules to avoid acting on those self-destructive urges.

With the Full Recovery Model, clinicians operate from the standpoint that when the original functions of the eating disorder

are understood and processed, when the eating disorder itself is replaced with meaningful relationships and passionate pursuits, when the effective coping skills fill in the earlier deficits…the eating disorder is no longer needed. A vivid picture of recovery can be found in 2 Corinthians 5:17: "Therefore, if anyone is in Christ, the new creation has come. The old has gone, the new is here!"

Perhaps more to the point is that people with eating disorders have to eat. Chemically-dependent sufferers can learn to live without their drug of choice. A relationship with food—a substance both loved and hated—is so complicated, but it is a must.

Most important to my view of the recovery process is the reality that the eating disorder itself can become deeply entrenched as someone's identity. And people will cling to it mightily, even if it is as "recovered" or "recovering" anorexic or bulimic. In my opinion, the ability to say, "I used to suffer from an eating disorder, but I am free today" is indicative of someone who is choosing to close that chapter of his or her life.

Are eating disorders similar to alcohol and drug addictions? Indeed, in many ways. Continually evolving beyond cookie-cutter approaches to treatment—of anything—is wise practice.

The Pursuit of Failure

Pursuing failure is one way of defining perfectionism. Perhaps that seems oxymoronic, but consider that when one's goal is to achieve perfection at all times and in all things, that person is doomed to fail. Nobody is perfect, and absolute perfection is impossible. Winston Churchill said, "The maxim that nothing matters but perfection is spelled p-a-r-a-l-y-s-i-s."

Many of my clients are afflicted with perfectionism, and yes, it is an affliction, and one that ultimately paralyzes! These people are constantly berating themselves for the slightest mistake, and they never feel good enough. Their identity is based on performance, and when that performance is flawed, self-esteem plummets.

I make the distinction between perfectionism and the healthy pursuit of excellence. In pursuing excellence, we are doing our best, but we can accept our limitations. The difference lies in the motivation. The perfectionist is motivated by fear: fear of failure, fear of rejection, fear of not measuring up to some internal or external expectation. One whose goal is excellence is motivated by a desire to achieve in order to learn, to grow, to improve. In sports or at work or in extracurricular activities, he or she is motivated by a love of that particular endeavor. There is peace in knowing one is doing what he or she is called to do.

In Philippians 3:12, the Apostle Paul tells us, "Not that I have already obtained all this, or am already perfect, but I press on to make it my own, because Christ Jesus had made me his own." (ESV) Only Christ was perfect. As we grow in becoming more Christ-like, we have a goal for which we are aiming, but we know that we will not be perfected until we see Him face to face.

Often we make messes out of our lives, or we somehow find ourselves in the midst of a messy situation. There are times when it's best to embrace the mess, for God can bring order out of chaos. Thankfully, He does not wait for us to "clean up our act" before we come to Him. We are admonished to imitate Christ and to grow in spiritual maturity, but it is only through the power of the Holy Spirit working in us that this happens. Because of Christ's sacrifice, we are made perfect (righteous) in God's sight, but the process of becoming holy is a daily one. Psalm 138:8 declares, "The Lord will fulfill his purpose for me; your love, O Lord, endures forever—do not abandon the works of your hands." (ESV) We are works in progress.

So, as we pursue excellence, let us not fall into the perfectionism trap which paralyzes us with fear. Former Archbishop of Canterbury Geoffrey F. Fisher wisely observed: "When you aim for perfection, you discover it's a moving target."

Mind/Body/Soul

Our bodies respond to our thoughts, feelings, and actions. This is a simplified way of explaining the mind-body connection, or more precisely—the biopsychosocial model, an approach positing that health is a combination of biological, psychological, and social factors. Here I address the spiritual facet of recovery.

Spirituality, in its broadest sense, can be defined as that which gives meaning to one's life and often draws one to connect to God or a Higher Power. Spirituality connotes a concern for the unseen and intangible, as opposed to physical or mundane. It also has to do with deep-- often religious--feelings and beliefs, including a person's sense of peace, purpose, connection to others. (adapted from Holistic Nursing Practice and the National Cancer Institute)

Therefore, this would include but not be limited to, Christianity or any other organized religion. My purpose is to highlight how spirituality in any form can be a very important component of eating disorders treatment. As a Christian, I place a high value on how my own religious beliefs and spiritual practices have influenced my recovery.

One example of a spiritual discipline that makes some Christians nervous is yoga. However, yoga is not a religion, and participation

in yoga is not at odds with Christianity. As a spiritual and physical practice, yoga addresses the integration of body, mind, and spirit; as such, it is a valuable instrument to promote one's spiritual well-being. Feuerstein, an internationally-known author on his interpretations of yoga, describes it as a "systematic program for peaceful living with sharpened self-awareness." Isn't that one aim of therapy?

At one stage in my healing journey, yoga became a critical piece in moving beyond a "stuck" point. I was having trouble with body image; also, I was not very skilled at identifying my emotions and knowing what to do with them once they were identified! I, like many eating-disordered individuals, lived entirely in my head, with very little awareness of what might be going on deep within my psyche. Surprisingly, yoga helped me learn to be at home in my own skin and tapped into such vast reservoirs of emotions that I would often cry in certain poses. Laura Meagher of the Inner Door Center says that in yoga, "we practice balancing effort with ease. In your healing process, you may find yourself in many uncomfortable moments. Your yoga practice is a metaphor for these uncomfortable situations. As you move into certain poses, they may feel awkward and challenging. As you begin to let go of your attachments, you can surrender into your healing work."

There is such difficulty among ED clients with being still…being alone with their maddening thoughts and the overwhelming drive to *flee*. Yoga balances the nervous system and stills the mind, usually with a focus on breath, the bridge from our bodies to our brains. In traditional yoga, breathing exercises and postures culminate in the act of meditation. So, spiritually, yoga helps still a restless mind and a restless body. For the Christian, acquiring that skill would certainly enhance his or her prayer life. According to Thomas Ryan, CSP, that's part of its attraction for westerners: it gives fidgety activists something to do that is actually very peaceful and calming. Scripture tells us to "be still and know

that I am God" (Psalm 46:10)

Another treatment modality is acupuncture, and along with this, herbal remedies. Acupuncture is a set of procedures which usually involve inserting tiny needles along certain pathways in the body in order to restore the balance of "qi," the energy force present in all of us. Qi consists of the physical, mental, emotional, and spiritual aspects of life. When qi becomes blocked, illness develops. Acupuncture and herbal remedies are major components of Traditional Chinese Medicine, which is thousands of years old but gaining respect with conventional medicine as evidence-based research shows its effectiveness. TCM can be used to treat anxiety, for example, a commonly co-occurring diagnosis with eating disorders.

Apprehension and fear may keep Christians from seeking less conventional, though potentially beneficial, avenues of healing. Why would we not question and scrutinize the training, credentials, and expertise of practitioners of Western medicine the same way we do those of the centuries-old Eastern approaches? These "alternative" therapies value the wisdom of the body and draw upon one's own inner resources of healing. This should appeal to followers of any faith who believe in a Creator and/or are taught to value and care for their "jars of clay." (2 Corinthians 4:7)

What's Your Problem?

"Why can't you get it together?"

"I'm trying everything I know to get a grip on my food problem."

"We are sick of your problem."

"What is my problem?"

People get lost in the search for solutions to eating disorders. This is true of sufferers, their family members, and loved ones. I hear comments like the ones stated above all the time, usually from sufferers and significant others when the battle gets too heated. What happens is that the focus returns to the tangible: food. I emphasize approaching this issue from a different angle.

As the sufferer of anorexia, bulimia, or binge eating disorder grows more impatient, frantic, and discouraged in his or her fight against the disease, there is often a return to the original way of viewing the eating disorder, i.e. it's about food. Yes, it manifests in unhealthy ways of dealing with food, but the search is for the solution to the wrong thing—the food problem. What is wrong is her feelings and not knowing how to handle them or how to deal with situations that arise. Food has become the default solution, but he has trouble identifying what the real problem is in the first place, e.g. lacking coping skills, knowing how to express oneself,

managing emotions, etc.

So, well-intentioned loved ones will throw suggestions at the identified patient: try this meeting or this book or this diet. Those can be wonderful adjuncts in the process of recovery. However, think of these suggestions as ways to learn to cope, to deal, to feel, to learn but not necessarily ways to "eat right."

There are hundreds of diets out there. We see them come and go. Jenny Craig, Weight Watchers, the Paleo Diet, Atkins, South Beach, Mediterranean, vegetarian, vegan; then there are diet pills and supplements. Why do they come and go? Well, without getting technical, diets don't work, at least, not for the long haul. People with eating disorders usually develop their illness from going on a diet. That doesn't mean that dieting causes eating disorders, or that there aren't multifactorial issues at play. There are. The common denominator, though, is typically a diet. And when the work of recovery (including therapy) becomes too difficult and not instantly gratifying, these sufferers want to go right back to a diet in order to "fix" things.

Again, they have missed the problem. Developing an eating disorder is much more complicated than a diet gone awry, and recovering from one is much more complicated than finding the perfect diet. It's more complicated than finding the perfect solution! In fact, perfectionism could be part of the problem, but that's a topic for a different article. When stuck on finding the solution, perhaps try asking a different question.

"Having positive body image isn't believing your body looks good; it is believing your body is good, regardless of how it looks. It isn't thinking you are beautiful; it is knowing you are more than beautiful. It is understanding that your body is an instrument for your use, not an ornament to be admired." -- Lindsay Kite, PhD

Warfare

In the book of Ephesians, the apostle Paul talks about spiritual warfare and describes the armor of God that believers are charged to wear in their stand against the devil's schemes. In Chapter 6 we read, "For our struggle is not against flesh and blood, but against the rulers, against the authorities, against the powers of this dark world and against the spiritual forces of evil in the heavenly realms." (Ephesians 6:12) This invisible armor includes the belt of truth, the breastplate of righteousness, feet fitted with the gospel of peace, the shield of faith, helmet of salvation, and sword of the Spirit. As Pastor Mark Smith in Jackson, Mississippi, observed, God made no provision for one's backside. Why? The answer is that God has made no provision for retreat. He has given us everything we need to be strong and successful in this spiritual battle.

Likewise, in recovery, we are to understand our enemy if we are to stand ready to face his attacks. The person struggling with an eating disorder is actually not in a battle with his or her flesh (the body), but is instead fighting unseen forces. These attacks may come in the form of "fat feelings," lies, and distortions about one's worth and value. All of this feels very real, and then we wage war against our own bodies. We give in to perfectionism, inferiority feelings, trying to become someone other than who we

were created to be. In doing so, we lose sight of the real enemy.

We are to make no provision for relapse, either. In her second memoir *Goodbye Ed, Hello Me*, Jenni Schaefer advises readers to remember this: "Don't have a backup plan." Just as we are to have no provision for retreat in our Christian walk, we shouldn't settle for a mediocre version of recovery. Find what it takes to stay committed to full recovery. That armor might include a treatment team, a support group, a meal plan and dietitian, a practice of journaling, a supportive relationship. The bottom line is that we are in a war and we need to do whatever it takes to stand firm.

It's Complicated

"When she was a little girl, she had to have everything arranged in her closet according to color and size."

"She always seemed to take things much harder than others."

"If he didn't get an A, he wouldn't speak for an entire day."

These statements are typical of the type of observations made by the parents of eating-disordered individuals, sometimes decades later. We come into the world hardwired to have certain personalities. These predispositions are then modified, altered, strengthened or sustained over time.

One's perceptions and reactions to events, both benign and traumatic, combined with his or her unique physiology, can contribute to the development of an eating disorder. Notice that I've made no mention of food, diets, or the media. It's not that those are not important factors; they are. The point is that eating disorders are complicated.

Predisposing factors such as personality type, grief and loss; precipitating factors, including puberty or going on a diet; and maintaining factors, e.g. anxiety management or fear of change, are all pieces of the puzzle. These are complex illnesses that require multi-faceted treatment strategies because every human

being is complex. Let's not reduce a life-threatening psychiatric disorder to something as simple as "a diet gone awry."

Eating Disorders Awareness and Prevention

A five-year-old complains that she's fat. An eighteen-year-old girl has the bones of a sixty-year-old woman. A man arrives in the ER with a ruptured esophagus. A young mother visits the dentist for her third set of crowns. A thirty-year-old dies from cardiac arrest. What is the common thread in these scenarios? An eating disorder.

February is National Eating Disorders Awareness and Prevention Month. Anorexia and bulimia have the highest mortality rate of any psychiatric disorder, and these illnesses affect over ten million females and one million males in this country. The physical complications of eating disorders include osteoporosis, dental erosion, fertility problems, organ damage, electrolyte imbalances, and heart failure.

In addition to anorexia and bulimia, there are other forms of disordered eating that also cause extreme psychological, interpersonal, and spiritual distress. Binge-eaters turn to food to comfort or numb themselves, chronic dieters define themselves by the number on the scale, compulsive exercisers neglect family and friends in order to stick to a rigid workout schedule. Many

of these sufferers slip "under the radar" because their symptoms do not appear to be life-threatening. However, they can benefit from counseling in order to improve quality of life or to prevent a continued downward spiral. Early intervention is critical to ensure recovery from these conditions.

Eating disorders are not simply about food and weight; the preoccupation with these topics serves to mask deeper troubles with self-esteem, overwhelming emotions, and out-of-control situations. Our culture preaches that our worth is based on appearance and achievements. "For man looks at the outward appearance, but the Lord looks at the heart" (1 Samuel 16:7). An eating disorder provides security in the storms of life but soon becomes an obsession that only brings misery. The recovering person learns that worth and value stem from being a child of God, a new creation in Christ. However, this is a long process, as one must be "transformed by the renewing of the mind" (Romans 12:2). Therapy involves nutritional counseling, exposing and correcting faulty thought patterns, and healing old wounds. Family counseling, assertiveness skills training, and body image work are often part of the process as well.

As a counselor, my mission is this: "Build up, build up! Prepare the road; remove the obstacles from my people." (Isaiah 57:14) The eating-disordered individual has encountered obstacles on the path to fulfilling his or her God-given purpose, and help is needed to clear the way. She must learn to identify and express emotions, practice self-acceptance, and fully grasp God's unconditional love. The freedom that recovery brings is reflected in Psalm 107:14, "He brought them out of darkness and the shadow of death, and broke their chains in pieces."

Picture the five-year-old child thinking she is fat; imagine her becoming the eighteen-year-old with osteoporosis. Imagine her heart failing from malnourishment and repeated vomiting.

Now imagine that this child is yours. Get help. To find out more about eating disorders or for ideas on how to promote Eating Disorders Awareness Month in your school or community, go to www.nationaleatingdisorders.org

No Rules

When discussing Christianity, or any other religion for that matter, a topic that is raised is legalism, i.e. strict adherence to the law, especially stressing the letter of the law over the spirit of it. In other words, this refers to abiding by rules in order to achieve favor with God or to atone for an offense. Christianity is not about rules but rather a relationship with God through His son Christ Jesus. There is great freedom in that.

In the same way, recovery from an eating disorder is not about rules. It is not about eating the "right" foods in the "correct" amount at the "best" time. Since so many eating disorder sufferers tend to be perfectionists, they think they must recover "perfectly." There is no perfect way to recover, and in fact, what works for many people may absolutely not work for others. Furthermore, in the process of recovery, slip-ups and relapse are often part of the process. Getting back up, dusting oneself off and getting back on track can take more courage, determination and hard work than simply staying the course. Mistakes can be our best teachers if we learn from them. Getting discouraged and giving up happens all too often when perfectionistic people approach recovery the way they have approached everything else in life, including the eating disorder. Recovery is not a linear process. There are twists and turns and periods of complacency and backpedaling. The person

who understands this and who is committed to the process will ultimately experience victory and freedom!

AMALI

(Swahili for "hope")

"No matter how long the night, the day is sure to come." –African Proverb

Love Heals

As a therapist, I believe this. Not love alone, but love is necessary and must bathe everything that is done in therapy. Solid treatment approaches applied in love heal. So, do therapists love their clients? I don't mean a romantic love, but a pure, benevolent concern for another's wellbeing. Applying 1 Corinthians 13 (aka "the love chapter") to the profession would seem to provide an affirmative answer to that question.

Love is patient, love is kind.

Love saved me from my battle with anorexia and bulimia. It came, among other things, in the form of a patient mom and a forbearing therapist.... *Love is not rude, it is not self-seeking;* it is not easily angered. Love understands that logic doesn't cut it. Reasoning with a person trapped in the eating disorder is fruitless. Love, not logic, is at the heart of the cure.

Ultimately, God, in His infinite and abounding mercy and grace healed me in the course of time. God is love, of course. So my task is to receive this love and extend it to others, including my clients. This can be frustrating at times, but love *keeps no record of wrongs. It does not delight in evil.*

Therapists must gently and lovingly challenge and confront

clients. We encourage them while respecting their resistance. In certain ways, we protect them. *Love always protects; always trusts.*

Recovering folks know love because they have been fed lies from the enemy about their worth. *Love does not envy; it does not boast; it is not proud.* The eating disorder lies and distorts, while *love does not delight in evil but rejoices with the truth.*

As a therapist, I must help clients persist and not give in and to trust that all this hard work is worth it. That is what love does. *Love always hopes; always perseveres.*

Love never fails.

Eating Disorders...from a Mother's Perspective

In an effort to promote awareness and prevention of eating disorders, I want to approach this disease from a different angle: from a parent's perspective.

"The main feeling you experience when your daughter has an eating disorder is FEAR," explains one mother. "You are confused, and terrified, and you feel utterly helpless."

Self-starvation, extreme weight loss, binge-eating and then vomiting, preoccupation with food and weight; these are some of the symptoms of the serious eating disorders anorexia and bulimia. Family members can become overwhelmed as they watch their loved one battle this illness.

"It seemed that anything we said or did in an effort to help was the wrong thing. Even though she was in and out of therapy, she just got worse." Eating disorders are complex physical and psychological disorders, typically affecting adolescents and young women. "It is impossible for other people to understand," said this mom. "Friends and other relatives would ask why we couldn't just make her eat. You feel a lot of guilt." The anorexic or bulimic individual relies on her symptoms to give her a sense

of control and self-esteem. It becomes an obsession that takes over her thoughts and feelings...and spins out of control. "It's almost as if a demon takes over your child."

This mother explains that eventually things turned around. "I think that her relationship with her therapist was the most important thing. She also needed to be hospitalized at one point, and I would advise parents not to be afraid of that. It saved her life. Even when she wanted to get better, it was still extremely difficult. Like most sufferers, she was a high-achiever, and we would think: 'She's so intelligent; she should be able to get over this.' There's more to it than that. It's an ongoing battle, and it takes a long time."

Eating disorders develop out of a combination of many different factors, such as genetics, family dynamics, social pressures, uncontrollable circumstances. Some parents mistakenly view their daughter's eating disorder as something shameful, as a poor reflection on their family. "What I needed most was just someone to listen to me."

Besides fear, confusion, guilt, and helplessness, at times parents feel anger. "You have to understand that your child is not necessarily being defiant and rebellious; she's dealing with something very frightening."

Medical and psychological interventions, along with a great deal of prayer, persistence, and patience brought an end to this nightmarish struggle. "Today my daughter is happy and healthy and continuing the process of recovery." "Be joyful in hope, patient in affliction, faithful in prayer." (Romans 12:12)

Lessons from Cats

I'm a mother to a fur baby (a cat) and "Jack" never ceases to teach me something new. For instance, an eye infection caused me to research cat's eyes, and I learned that cats have the ability to see shades of gray. That jumped out at me because eating disorder sufferers are notorious for thinking in extremes: black or white, all or nothing. "I'm either fat or thin; I either binge or starve; I either over-exercise or do nothing." Part of therapy involves learning to see the shades of gray in life.

When my baby continued to cry and beg and whine for food not long after being fed, I picked him up and said, "Jackson, (his name when I am serious), you are not hungry." And we sat down in the rocking chair and rocked in front of the fire. As he lay in my arms purring and purring his sweet self to sleep, I thought, *How like us humans. We think we are hungry and we run to food. Anxiety swells up within us and we run to food.* Often, maybe we're simply cold, or tired, or need a loving touch. Maybe when we think we are fat, and do everything to avoid food, it likely signals another unmet need.

Learning to identify needs and emotions and sensations is critical to recovery. Having someone trustworthy to help a sufferer pause, slow down, and check in with him or herself is invaluable.

Perhaps we could all learn lessons from our fur babies!

Pet Therapy

The official name for this is Animal-Assisted Therapy. I refer to it as "pet therapy" because I utilize my pet cat, Jack. Advocates of this type of therapy find that developing a bond with an animal can help people develop trust, stabilize their emotions, and improve their communication and socialization skills. Animals can provide a sense of calm, comfort, and safety. God placed value on animals. Proverbs 12:10 says that "the righteous care for the needs of their animals, but the kindest acts of the wicked are cruel." Furthermore, in 2 Samuel 12, Nathan rebukes King David by telling a story about a man who raised a little lamb with his family; he cuddled it in his arms like a baby daughter. This tells me that even in biblical times, people had pets.

When Jack was a kitten, I had a client who could only participate in the session if she could hold him. This adult woman had never even heard a cat purr, and his "motor" calmed her and provided that needed connection, almost like a bridge to me.

Another client bonded with Jack before she could bond with me. She was always rushing to pet him upon entering, and he would run away terrified. I explained, "Jack is slow to trust, just like you." She would make it a point to engage with Jack each week, once telling him "I get you." Slowly she began talking to me and now easily chatters and confides in me. Oh, and Jack

lets her pet him now; he doesn't run away!

It has been said that the opposite of addiction is connection. As people trapped in addictions to substances or processes (such as eating disorders) learn to relate to, connect to, and work with animals (many treatment centers provide equine therapy), they can translate those healthy, low-stress social interactions into meaningful human relationships.

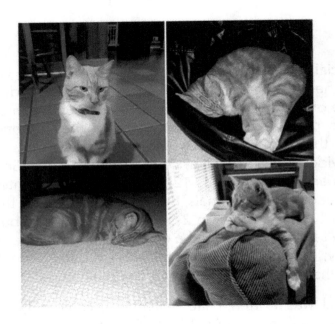

Jack greets clients. Jack on the lookout for clients. Jack off-duty, resting.

The Devil Is A Cockroach

Years ago, Pastor Chip Henderson of Pinelake Church in Brandon, Mississippi, delivered an analogy that made a lasting impression on me. He recalled how he, as a young seminary student renting a room out of an old house, unfortunately had to share quarters with cockroaches. Roaches are disgusting creatures (not sure why God created them, but that's a topic for another day), but they cannot actually hurt us humans. They carry germs and diseases, but they don't bite or sting or cause bodily injury. And when you turn the lights on, that's when they usually scatter. Chip's point was that this is how the devil operates in our lives. He can't directly hurt us (apart from what God allows within the confines of His divine providence). No, instead he deceives us. If satan can get us to believe a lie, then he has us right where he wants us.

From a psychological perspective, the eating disorder works similarly. It whispers in the ear of the sufferer: "You're not good enough, not thin enough, not pretty enough…and therefore, you are not enough." Or "You can't handle these emotions or difficulties without channeling them through me." Or "Life will never improve. You'll always be lonely, heartbroken, abandoned, forsaken." Only by relying on this disorder, one believes, can he or she find meaning, purpose, or joy. What a lie! When we hold

that up against truth, exposing it to the light, we see it for the falsehood that it is.

"The light shines in the darkness, and the darkness has not overcome it." (John 1:5)

God gives us His mercy, grace, and direction to lead us through painful circumstances, to heal damaged emotions and wounded hearts. We can safely relinquish control to a loving God instead of tightening our grip on a debilitating disease, believing that is the answer when it's actually worsening the problem.

The evil one traps you by convincing you to believe a lie. That is what the eating disorder does. Remember your true enemy. Walk in light, and walk in freedom.

Coloring Outside of the Book

I was new to the adult coloring book craze. I've always encouraged creative expression in my clients, believing in its powerful role in the healing process. Music, dance, art (yes, coloring) are all outlets that I feel are important and that I have embraced for years. So when I learned about this "movement" and all its supposed benefits, e.g. achieving bliss, relaxation, etc., I was excited to buy a coloring book for adults!

And then I was really disappointed. And frustrated. And confused. Was I doing it wrong? Overthinking it? I was coloring myself crazy! I decided to buy a different kind. Maybe if I colored landscapes instead of geometric patterns, that would help. Well, it did—a little. I still wasn't enjoying it, much less experiencing a state of relaxation. So one day I just started coloring. Then doodling. Then drawing with my non-dominant hand. These were all the things that I used to do! This was fun, relaxing, and stress-relieving. For me, that was the key: throw out the book and let my own creativity come out to play.

In recovery, freedom comes when we learn that it's okay to break the rules—especially rules that are borne out of perfectionism, people-pleasing, and performance. Aren't those three elements part of the main focus when it comes to eating disorders? Experimenting with the adult coloring books helped me relearn

and rediscover this. Perhaps most importantly, I was reminded that what works for one person doesn't necessarily work for the next person.

And that's okay.

Labels

Three issues that repeatedly come up in the news or in social media have to do with Body Mass Index (BMI), nutrition labeling on foods, and calling women of a certain weight and build "plus-size."

As a clinician treating eating disorders, these issues really frustrate and anger me.

We do have an obesity epidemic in this country to be sure, and the BMI is one way of determining who may fall into this category. It's calculated using one's weight and height. The main flaw: It's an indirect measure of body fat that doesn't consider important details about age, sex, bone structure, and fat distribution, one study in the *Journal of Obesity* explained. Again, it's just two numbers: weight divided by height squared.

Many athletes would be classified as obese because of their muscle and bone mass. Several school systems in our country have sent home "report cards" on children, using only the BMI to basically label a child as "fat." There is no good reason to subject anyone to the potential body image disturbance that could come with such an arbitrary measure.

Nutrition labeling helps consumers make informed choices about

the foods they eat, presumably so that they can make healthy dietary choices. As with the BMI, when education and wise discretion is applied, this is useful. However, in the U.K., there was recently a proposal to include in food labeling how much exercise is needed to burn off calories consumed. Again, this does not take into account individual differences in metabolic rate that come with age and gender. Presumably, the labeling would encourage people to exercise and would promote health. I highly doubt that this would be the consequence; instead, it could actually be a deterrent to exercise! Also, there is much more to a healthy food choice than calories alone.

For eating-disordered sufferers who are already obsessed with numbers, this could actually be deadly. Eating is not a math equation!

And finally: labeling models, clothing, or people (usually women) in general as "plus-sized" needs to be eradicated, in my opinion. The average woman is larger than the fashion industry's definition of what is acceptable or beautiful. I'm not going to get into numbers here (my website is www.nomorenumbers.com for a reason), but typically, a runway model who simply has curves is called a plus-sized model.

And we wonder why girls have body image disturbances.

Scale courtesy of client Julia.

Press On

I have learned to be grateful for my eating disorder, for it has been one of my greatest teachers. No, I'm not grateful for the suffering that accompanied this illness or the heartache that it caused my family. I'm not grateful for the toll it took on my health or my relationships. I'm not glad that I spent many months in treatment centers over the course of years, missing key events like my college graduation.

However, the lessons learned through suffering are usually the most profound and most important. Going through the recovery process yields its own fruit, a harvest of gifts, so to speak, that many people may never acquire: an understanding of one's values and ideals and what is most important in life, learning how to assertively say no, the ability to identify and express emotions. These are essential life skills that one might not learn otherwise. One has to do the hard recovery work, though. Robert Frost wrote, "The best way out is always through."

It is in coming to a place of surrender that one finally has to look up and humble himself and allow God to do His transforming work. "I don't mean to say that I have already achieved these things or that I have already reached perfection. But I press on to possess that perfection for which Christ Jesus first possessed me." (Philippians 3:12, NLT)

What I want my clients to learn is that we don't want to hate this eating-disordered part of ourselves. The eating disorder developed as a way to help one survive, to cope. It's a maladaptive way of coping, to be sure, but when we look back on the purpose it served, we find that it was taking care of the person who knew no other way. In recovery, we learn new ways to get needs met. We learn to respond to old triggers in new ways. We learn to have our feelings and not be ruled by them.

Author Karen Koenig has said, "The irony is that if you give them half a chance, your deepest heartaches might just pave the way to your greatest happiness."

I would not wish this disease on anyone, but if we believe Romans 8:28 (that God brings good out of every bad situation for His children), then we must seek to uncover the tapestry God has woven together. This is the most important lesson of all: in the darkest of days, God never left me or forsook me, just as He promised. And because of that, I can live out what is taught in 2 Corinthians 1:4: "He comforts us in all our troubles so that we can comfort others. When they are troubled, we will be able to give them the same comfort God has given us." (NLT)

Persistence

"Let us not grow weary in doing good, for at the proper time we will reap a harvest if we do not give up." (Galatians 6:9)

Eating-disordered folks are notoriously stubborn. A key task is figuring out how to channel that trait into something positive and constructive. We may need to tweak the adjective "stubborn" to "persistent" or "determined" or "tenacious" and learn to utilize this trait in a healthy way so that we can embrace it.

My clients teach me the value of persistence. I see them learn how to wait on God and trust Him for something, learning that His timing is perfect. I witness their courage in overcoming obstacles, moving from victim to survivor to "thriver." During this process, they may even learn to thank God for the problem plaguing them. As they put into practice what I preach, I learn from them how to apply the same principles to new and different areas in my life.

Running Differently

I used to be a runner. I loved racing, and I loved the joy, freedom, and clarity of thinking that a good run could afford me. Then I got a hip replacement and had to end my running career. I now appreciate a good, brisk contemplative walk, with some jogging thrown in there.

When I was coming to terms with this change in my body and my lifestyle, I found several scriptures in the Bible that use the word "run" or "running" as a descriptor or metaphor.

In Proverbs we read, "The name of the Lord is a strong tower; the righteous run to it and are safe." (Proverbs 18:10, ESV) In Isaiah there is this famous passage: "those who hope in the Lord will renew their strength. They will soar on wings like eagles; they will run and not grow weary; they will walk and not be faint." (Isaiah 40:31, NIV)

We run from our problems and fears, as Hagar ran from Sarai in Genesis. Later in the New Testament, in the Garden of Gethsemane, all the disciples deserted Jesus and ran away.

The Bible tells us to flee from temptation; flee the evil desires of youth. We are to "throw off everything that hinders us and the sin that so easily entangles and run with perseverance the race

marked out for us." We must keep our eyes on Jesus and not our circumstances or ourselves.

The race metaphor is one that is used repeatedly in scripture. "Do you not know that in a race all the runners run, but only one gets the prize? Run in such a way as to get the prize." (1 Corinthians 9:24, ESV). We need to run with purpose and discipline. Work and preparation are involved in running towards our heavenly reward.

Paul wrote that he "fought the good fight; finished the face; kept the faith". He wrote in Acts: "I consider my life worth nothing to me, if only I may finish the race and complete the task the Lord Jesus has given me—the task of testifying to the gospel of God's grace."

So, we need to ask ourselves: What am I getting out of this particular race I am in? Recognition, fun, money, success? Or am I pursuing righteousness, faith, love, and peace? When we fall off track, we must ask ourselves the question posed in Galatians, "You were running a good race. Who cut in on you and kept you from obeying the truth?" What voice are you listening to? Stay focused.

Finally, the theme of persevering and discipline suggest that it takes more faith and yields greater rewards to go through a trial than to expect an instant miracle. Keep putting one foot in front of the other, running the race marked out for YOU.

I used to worry about winning the race; now I know I always win if I "run with endurance the race set out for me." (Hebrews 12:1, NLT)

The Ultimate Irony

"And we know that in all things God works for the good of those who love Him, who have been called according to His purpose." (Romans 8:28) This was my mother's favorite verse. It used to really bug me when she would toss that around. Well, with the passage of time come wisdom and the ability to reflect and see the evidence of how this promise manifests. (Okay, you were always right, Mom.)

I sprained my wrist quite badly last summer, and it took forever to heal. I knew that in the grand scheme of things, this was not that big of a deal, but it was rather debilitating and keeping me from many activities that I enjoy. A few short months after that, I managed to dislocate my shoulder—a shoulder that had once undergone surgery for a torn rotator cuff. After being rushed to the ER in order to "pop" it back into socket, I was in something of an immobilizer for some weeks while awaiting my fate, i.e. was I going to need more surgery? I earnestly prayed, begging God to spare me the awful surgery and rehab (and He, in his infinite mercy) did! This time I had only partially torn the cuff and would only require physical therapy. I realized then why God had allowed the bad wrist sprain. Otherwise, I would have continued doing all of the things that would have ultimately led to my completely tearing the rotator cuff and needing extensive surgery.

Years before that, my husband was diagnosed with a pituitary tumor (a benign brain tumor). Two prominent neurosurgeons refused to perform surgery on him due to the sheer size and location of the tumor. Praise God! We were led to the very best neurosurgeon in the state, one of the best in the world! My husband was a walking/talking miracle after surgery done by that man.

A few years ago, my husband lost his job after sixteen years with the same company. We couldn't understand why God had allowed this. He used to sometimes joke, though, that he wished he could just go work at the hardware store. Guess where he happily works today? The hardware store!

In my den, there is a clock that I bought for my very first apartment some twenty-five years ago. There's nothing inherently special about this clock, I just thought it was cool. Well, it died a few years ago and new batteries did not solve the problem. When my mom was going through chemotherapy, I would call her every morning at 8:30. So, a couple of months after her death, I kept walking back and forth through my house, thinking of all the things I needed to accomplish but couldn't seem to get done. "I can't even do anything with this stupid clock that is stuck on (wait for it) 8:30!" The clock remains.

Letter from My Twenty-Five-Year-Old Self

Recently, when going through some old papers, I found a "manifesto" of sorts, written early in my recovery and in my Christian walk. The newly-found joy and freedom I was experiencing was evident in this outpouring of my heart, a declaration of what my life would now look like.

Reading this after so long jolted me out of a complacency I was in – a rut, if you will – taking for granted the mercy, grace, and healing I had been given. Here are some of the things/resolutions I had so boldly claimed some twenty years ago:

-This year I will live in the moment and love every moment I live.

-I will focus on now instead of tomorrow by not dwelling on what could have been or worrying about what has not yet happened.

-Times of reflection and introspection will not swallow me into a pit of despair. I will use these to grow with more wisdom and character.

-All I can control is what I say and what I do. These begin in the mind. I will allow God to control my thoughts, with Christ in my heart.

-I will not obsess about food; I will thankfully and sensibly eat and enjoy it.

-I will not force myself to exercise; I will want to and will enjoy it.

-I will not pray for my circumstances to change; I will be content with my circumstances and change what I need to change.

-I will not worry about money. I trust God to provide and help me act wisely.

-I will not live my life for another person or because of another person. I will live my life because God gave it to me and created me for a purpose. I will live honestly and humbly and joyfully to discover that purpose each day. I will offer what I can to others I encounter and will allow God to work through me. I do not exist for another person or because of another person. I am complete in Christ.

-I will walk with Jesus, not behind him or ahead of him.

-I will not be afraid of the future. I will not fear the unknown. God knows.

-God's will is holy, acceptable, and perfect. I pray to live in accordance with that.

-I will thank God for friends, for all of the beautiful souls he has touched me with. I will pray for those whom I have difficulty befriending.

-I'm happy with all the bad, ugly parts of me and my past because I'm happy with me and my life today.

-Anorexia and bulimia don't rule my life now unless I let them. The disease is conquered and what I have left of it is scars. When I hear its menacing voices and accusations, it's the devil that is speaking, telling lies that I'm worthless, fat, ugly, stupid, and evil.

I'm tired of listening to those lies.

-This year I will be ever mindful of the goodness in my life. I will humbly remind myself that I am nothing apart from Jesus Christ, but that I am totally complete with Him. Material wealth, accomplishments, proper social circles, etc., don't matter to God so they shouldn't matter at all.

There was more, but I will leave it at that! My wise twenty-five-year-old self concluded with the well-known verse Jeremiah 29:11: "I know the plans I have for you," says the Lord, "plans for welfare and not destruction, to give you a future and a hope." (ESV)

I'm tired of listening to more noise.

This year I will be more mindful of the choices I make. I will simply react... that I... a chance apart from issues... best that I... totally correlate with something's meaning... economical than... operação models and... to master to do so the chance... within obtain.

There was one, but I will sleep... and for myself... me... myself connected with this well known voice. Jinn and to 9 M.I. "I know we" right is I save it you say, that I am... we are and not rest... you, to give you a chance at a larger... (CS)

When Willpower Won't Work

Whether we're talking about dieting, stopping smoking or reducing alcohol consumption, people tend to believe it's all a matter of willpower, an exertion of one's will. In addiction circles, the term "white-knuckling" is common: it refers to trying too hard; every day is a struggle.

Binge eaters and bulimic individuals believe themselves to be weak when they try not to give into their impulses around food. They will try really hard, and have some success, and then fall again and feel like failures. Anorexia sufferers are often praised for having such discipline, for having "willpower." Actually, this often reinforces the behaviors of the disease, behaviors which are not a result of having willpower. They're manifestations of obeying the cruel taskmaster in one's head. We're talking about a compulsion here: ultimately the person is powerless to stop (bingeing, purging, starving, over-exercising, etc.) without help.

So, when people enter into the recovery process, desiring to stop whatever-it-is, they get frustrated, *because they are forgetting their power source.* In Zechariah 4:6 (ESV) we read, "Not by power or by might, but by My Spirit," says the Lord Almighty." The thing is, willpower cannot match sin's power. Even when we're talking about not gossiping or cursing, our own "will" only gets us so far. It is when we surrender to the power of God's Spirit

that we find the strength and power to experience victory.

The apostle Paul writes, "For it is God who works in you to will and to act according to His good purpose." (Philippians 2:13). He goes on to say in Galatians 2:19-20 that "through the law, I died to the law so that I might live for God. I have been crucified with Christ and I no longer live, but Christ lives in me." The Message translation says it this way: "I was trying to be good; I would be rebuilding the same old barn that I tore down...I tried keeping rules and working my head off to please God, and it didn't work. Christ's life enabled me to do it. The life you see me living is not 'mine' but it is lived by faith in the Son of God."

We see this type of paradox throughout scripture: in losing my life, I find it. In humbling myself, I am exalted. In surrendering, I am victorious. Now that's power.

Licking the Spoons of Life

Remember when you were a kid and your mom or perhaps a grandmother would bake a cake, and if you were lucky, you got to lick the spoons? Or better yet, the eggbeaters? It was heaven!

God gives us little glimpses of heaven along the way: the beauty in a sunset, for instance. He could just "turn off the lights," but instead, we are given a magnificent display of pinks and purples and blues and golds, a different masterpiece every evening. Be thankful for all of these gifts! We are commanded to in Scripture: "give thanks in all circumstances; for this is God's will for you" (1 Thessalonians 5:18).

At the same time, may we not be content to settle. Let us not grow stagnant in our spiritual walk, but continue to mature and challenge ourselves. The same concept applies to recovery. Many people with eating disorders or other mental illnesses will accept symptom reduction or absence as the measuring stick for recovery (e.g. weight gain as the main criterion in anorexia nervosa or elimination of the binge/purge cycle in bulimia nervosa), when they could be experiencing a whole new level of freedom: learning from the illness in order to discover their true identity and purpose, continually expanding their horizons.

Often, we're tied to our old patterns of doing things, never

dreaming that God could have more in store for us. We stick to the tried and true because it's comfortable. Or, we may find that what so many are striving after is ultimately worthless. C.S. Lewis puts it this way: "We are half-hearted creatures, fooling about with drink and sex and ambition when infinite joy is offered us, like an ignorant child who wants to go on making mud pies in a slum because he cannot imagine what is meant by the offer of a holiday at sea. We are far too easily pleased."

It's been said that good things become bad things when we idolize them as the best things. Instead of patiently and openly waiting for the blessings God has planned for us, we allow frustration and fear to take hold, getting ahead of Him and missing out on His best.

Remember to rejoice in the Lord always—not in your circumstances, necessarily, but in the Lord (Philippians 4:4). Be willing to give up the remnants of chocolate in a mixing bowl and receive the whole cake!

Prisoners of Hope

"It is for freedom that Christ has set us free. Stand firm, then, and do not let yourselves be burdened again by a yoke of slavery," the Apostle Paul writes in Galatians 5:1. There are multitudes of Christ-followers who are forgiven of their sins because of their belief in the death and resurrection of Jesus, yet they are not free. Many (and this is what the text is referring to), are still chained to rules and regulations and "trying to be good enough" for God. I take it a step further and say that many of us find that our prisons, though perhaps not built of iron bars, are comfortable, predictable, and in many cases, safe. The prison of my eating disorder was safe and comfortable and predictable, until it was none of those things.

In Isaiah 61:1, we read the prophecy fulfilled by Jesus' words in Luke 4:18: "(Jesus) was sent to proclaim freedom for the captives and release from darkness for the prisoners."

We are free as American citizens, free as forgiven Christians, but still enslaved to addictions and compulsions, or slaves to ritualistic laws and regulations. None of these things make us more acceptable to God; nor do they allow us to experience the full, abundant, free life that Jesus came to give us (John 10:10). I am even referring to the "rules and laws" of eating-disordered thinking: I must have x number of calories; I must counter that

with x amount of exercise; I must adhere to this list of "good" and "bad" foods.

2 Peter 2:19 says, "For people are slaves to whatever has mastered them." A few verses earlier he writes that we "must live as free people but do not use your freedom as a cover-up for evil." In fact, he says to live as God's slaves. Wow, that sounds a little harsh. However, when we understand who God is and His goodness towards us, this is not the death sentence that it sounds like upon first glance.

He is right: We are slaves to whatever has mastered us: food, drugs, and compulsions of every variety. Consider 2 Corinthians 3:17, "Where the Spirit of the Lord is, there is freedom."

Freedom! Isn't that what we all long to experience? We find it wherever God's Spirit is. Well, let's seek it! The believer's freedom says that "everything is permissible for me, but not everything is beneficial." So, I am allowed to do this or that activity, but I, with the discernment of the Holy Spirit, need to determine whether or not this is a good, wise, or helpful thing to do.

Zechariah 9:12 says, "Come back to the place of safety, all you prisoners of hope. I promise this very day that I will restore twice as much to you." (NLT) We are prisoners of hope! That sounds inviting, not binding or limiting or cruel. We have the assurance of things hoped for. No good thing will God withhold from those who walk uprightly. (Psalm 84:11).

To all who have been subjected to the prison of an eating disorder, know that freedom awaits you, if you seek it and search for it and ask others to come alongside in you in this pursuit of hope and freedom.

The Power of Forgetting

There are benefits to forgetting the past.

In Philippians 3:13-14, Paul writes that he has not achieved the goal of perfection, but he focuses on this: "forgetting the past and looking forward to what lies ahead, pressing on to run the race to receive the heavenly prize." (NLT) The Word instructs us not to focus on past failures or successes and achievements, but instead to keep focusing on what God has called us to do now. We can put the past behind us; what a relief!

On the other hand, there is a very real danger in forgetting from where we have come. "Where a man's wound is, that's where his genius will be," writes poet Robert Bly.

If we don't remember what we have been delivered from, we run a very real risk of returning to it when difficult circumstances close in on us. We have the uncanny ability to deceive ourselves, and satan capitalizes on this, as his main weapon is deception. People recovering from eating disorders, addictions, and so forth can forget how bad it was and start romanticizing the glory days.

In the Old Testament, the Israelites demonstrate this time and time again. For example, in Deuteronomy 8:8-20, we read, "Be careful not to forget the Lord your God, failing to observe his

commands; otherwise, when you become satisfied [with physical things], your heart will become proud and you will forget the Lord your God, who brought you out of slavery!" The priest Ezra later laments over the people's return to sin after God, in his unfailing love, rescued them from murder and capture. God graciously gave a remnant of these people another chance.

Psalm 106 tells how God parted the Red Sea, saved His people and redeemed them from the enemy. "Then Israel hastily forgot His work and what he had done and didn't wait for his counsel." AMPLIFIED BIBLE, CLASSIC EDITION.

Aren't we just like that? We forget how good God is to us, and return to things that don't satisfy, when, like the Prodigal Son in Luke 15, everything we ever wanted and more is available to us when we run to the arms of the Father!

It has been said that there is a God-shaped vacuum in the heart of every person, and only God can fill it. Because of God's grace, we don't need to keep looking back, ruminating over the past. He "forgets" our sin, and so can we. However, don't forget where you came from so that you keep growing, changing, and moving onward!

A therapist and client must work in tandem. That means we must work together, in partnership, collaborating with one another, staying in sync.

"Be happy everyday...because it goes so fast." —My mother's last words to me

#Restored

He makes all things new! He has made everything beautiful in its time.

"Therefore, if anyone is in Christ, the new creation has come. The old has gone, the new is here! (2 Corinthians 5:17)

CPSIA information can be obtained
at www.ICGtesting.com
Printed in the USA
LVHW042226280323
742729LV00014B/738

9 781640 882010